TRADEMARKS OF THE
40's AND 50's

TRADEMARKS OF THE 40's AND 50's

BY
ERIC BAKER & TYLER BLIK

INTRODUCTION BY STEVEN HELLER

CHRONICLE BOOKS

SAN FRANCISCO

Printed in Hong Kong.

Cover br Michael Doret

Library of Congress Cataloging in Publication Data:

Baker, Eric 1949-
 Trademarks of the 40's and 50's.

 1. Commercial art– United States– Themes, motives.
2. Trademarks– United States– History– 20th century–
Themes, motives. 3. Decoration and ornament–
United States– Art deco– Themes, motives. I. Blik, Tyler.
II. Title. III. Title: Trademarks of the forties and fifties.
NC998.5.A1B36 1988 741.6 88-6142
ISBN 0-87701-485X (pbk.)

Distributed in Canada by
Raincoast Books
8680 Cambie Street
Vancouver, B.C. V6P 6M9

10 9 8 7 6

Chonicle Books
85 Second Street
San Francisco, CA 94105

www.chroniclebooks.com

We would like to thank the following people for helping to make this book a reality: Bonnie Resnick, Vickey Hanson, Gale Collins, Chris Millard, Ken Soto, Lee Goodman, Michael Doret, David Barich, Fearn Cutler, Steven Heller, the staff of the Science and Industry Department of the San Diego Public Library, and especially all of those anonymous designers whose work this is all about.

Eric Baker, New York
Tyler Blik, San Diego

Table of Contents

42

Science & Industry

66

Animals

78

Circles & Shapes

122

Typography

Introduction

The common complaint about today's corporate logos and trademarks is that they are too conceptual, geometric, and generic; gone are the distinctive characteristics that business requires to distinguish itself. Many of the once emblematic, cartoonlike trade characters prevalent in early corporate identities have been replaced by Swiss style typography or cold abstract forms. While nothing is inherently wrong with modernizing one's business image, it is nevertheless sad that so many of our venerable and friendly trade characters—some of whom you will see in this volume—have been retired or streamlined into simplified forms (witness the Bauhausian Quaker Oats man at your local supermarket).

Yet why shouldn't business keep pace with styles of the times? Commercial trademarks were never intended to be permanent monuments, but rather active symbols of current identity. Some of America's most memorable trademarks have decidedly outlived their usefulness.

Take for example the Campbell's Kids; for decades a consumer could not look at these red-cheeked youngsters without thinking of the wholesome goodness of Campbell's soup—at once they awakened the appetite and the buying impulse. Yet in recent years wholesome canned soup has lost its market share to other "health" foods, forcing Campbell's to aim at a new, sophisticated urban market. Dressing the kids (now in their late fifties) in Reeboks and Esprit was not the answer. Although the actual Campbell's logotype was only slightly fine-tuned, the kids are on indefinite leave and have been replaced by handsome, physically fit American men and women as the new role models. Without an investment in tradition, young consumers readily identify with the new symbols and, with the exception of some nostalgists, older consumers do likewise, so as not to be left behind.

Given these stylistic and conceptual changes, trademarks nevertheless continue to serve the same charged

purpose as when they were first used by craftsmen and tradesmen centuries ago. What differs, however, is the way trademarks are now created and the nature of the businesses they represent. When Lucian Bernhard designed his Cat's Paw mark he gave it to an advertising agent, who showed it to the company's owner, who decided to use it on the spot. There were no demographic surveys, no encounter groups, no middle management committees. But today trademarks are linked to costly and prestigious identity systems—communications consulting firms have replaced commercial artists. Moreover, multinational corporations are not effectively represented by friendly trade characters; instead, abstract signs and glyphs are an appropriate means of expressing diversification.

Such is the evolution of the trademark.

The examples in this book from the forties and fifties, most done anonymously, evidence a fascinating chapter in this evolutionary process. Some obviously mimic early twentieth-century motifs; others display wry wit in the manner of the skilled German designers of the twenties; and still others plunge headlong into the modern age with their use of Arpisms and atomic molecules. A few of these trademarks are still used today, but most are long retired. All, however, exhibit a curious graphic innocence representing the calm before the storm of high-tech, global enterprise that has changed the climate of business identity.

Steven Heller

1947
Consolidated Freightways, Inc.
Portland, Oregon
Moving Service

People & Figures

Our product is reliable, dependable, clean, and accurate. It's authentic, it has quality, and it gives you personality. This is what companies were saying to their customers, and what better way to show their identity than through the eyes of the consumer. Images of the farmer, the factory worker, the secretary, and the businessman were all symbols of what America stood for. The products and the services of the postwar era were abundant, and their appeal was conveyed with the gesture of an open hand or a friendly salute, suggesting to the buyer a sense of security and confidence. The cartoon or comic book character was ever present in the marketplace as the representative or spokesperson of a company. Behind these whimsical and capricious figures was an image that we could laugh and identify with, thus preserving that memory of the company's product or service.

1949
RCA Service Company, Inc.
Camden, New Jersey
Theater Sound Equipment

1946
Engineering Manufacturing Company
Sheboygan, Wisconsin
Drafting Equipment

1950
Mercury Record Corporation
Chicago, Illinois
Phonograph Records

1950
The Cooper Alloy Foundry Company
Hillside, New Jersey
Pipe Fittings and Valves

1950
Mirax Chemical Products Corporation
St. Louis, Missouri
Insulated Picnic Jugs

1948
Wilson & Stokes Lumber Company
Trenton, New Jersey
Lumber and Millwork

1947
Sleepwear, Inc.
New York, New York
Pajamas

1948
The Actus Corporation
Mount Vernon, New York
Hose Clamps

1948
Atlas Boxmakers, Inc.
Chicago, Illinois
Packing and Shipping Boxes

1952
Superior Paint and Varnish Corporation
Chicago, Illinois
Paint, Varnish and Enamel

1951
**The Brunswick-Balke-Collender
Company**
Chicago, Illinois
Bowling Score Sheets and Pencils

1948
**The Brunswick-Balke-Collender
Company**
Chicago, Illinois
Billiard Equipment

1940
J. D. Harris & Company
Cambridge, Massachusetts
Paints, Lacquers, Varnish and Enamels

1940
Lily-Tulip Corporation
New York, New York
Paper Cups and Containers

1940
Cortland Line Company, Inc.
Cortland, New York
Fishing Lines

1946
H.J. Hueller Manufacturing Company, Inc.
Brooklyn, New York
Oil Burner Units

1955
Mid-Co Photo Service
Wichita, Kansas
Packaged Photographs

1958
The FR Corporation
New York, New York
Photographic Film

1954
The Standard Overall Dry Cleaning Company, Inc.
Manchester, New Hampshire
Cleaning Work Clothes and Uniforms

1956
Master Vibrator Company
Dayton, Ohio
Space Heaters

1953
National Tailoring Company
Chicago, Illinois
Custom-Made Men's Wear

1957
The Asher Company
Fitchburg, Massachusetts
Men's and Boys' Trousers

1957
Altec Lansing Corporation
Beverly Hills, California
Speakers, Tuners and Amplifiers

1952
Post-Hall Syndicate, Inc.
New York, New York
Comic Strip

1940
Minnesota Macaroni Company
St. Paul, Minnesota
Macaroni, Spaghetti and Egg Noodles

1948
United Feature Syndicate, Inc.
New York, New York
Comic Strip

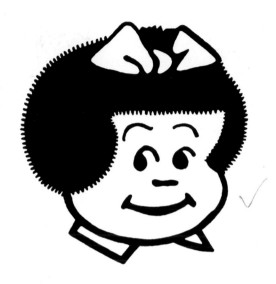

1952
Matthews Thrifty Lady Super Markets
Atlanta, Georgia
Packaged Dried Beans

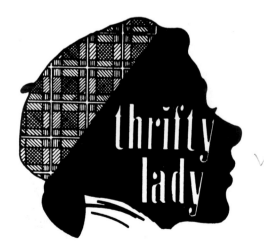

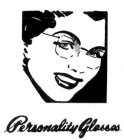

Personality Glasses

1945
Weisfield & Goldberg, Inc.
Seattle, Washington
Eyeglasses

1945
Revoc, Inc.
New York, New York
Cigars, Cigarettes, Pipe and Chewing Tobacco

1952
Audrey Treu
Ogden, Utah
Face Creams, Make-Up, Bath Articles

1947
United Fruit Company
Boston, Massachusetts
Bananas

1949
Queen Knitting Mills
Philadelphia, Pennsylvania
Strapless Halters and Women's Outerwear

1949
Jack Galter
Chicago, Illinois
Steam Hand Irons

1940
Mr. Newport, Inc.
Chicago, Illinois
Non-Alcoholic Maltless Beverages

1956
Dubonnet Wine Corporation
New York, New York
Aperitif Wines

1948
S. Rudofker's Sons, Inc.
Philadelphia, Pennsylvania
Boys' and Men's Clothing

1947
Allen B. Wrisley Company
Chicago, Illinois
Perfume

1955
Runnymede Mills, Inc.
Tarboro, North Carolina
Boys' and Misses' Hosiery

1955
The O-P Craft Company, Inc.
Sandusky, Ohio
Household Decoration Kits

1957
Ferno Manufacturing Company
Circleville, Ohio
Ambulance Cots and Morticians' Carts

1953
Patcraft, Inc.
Dalton, Georgia
Cotton Rugs and Carpets

1952
Kurt Orban Company
New York, New York
Twist Grill Grinding Machines

1953
Colonial Sugars Company
Jersey City, New Jersey
Sugar and Sugar Cane

Hefty Hammer

1954
Little Beaver Industries Inc.
Willoughby, Ohio
Shop Hammers

1949
Sterling Bolt Company
Chicago, Illinois
Bolts, Nuts, Screws and Rivets

1947
American Tag Company
Chicago, Illinois
Printed Tags, Labels and Tickets

1946
Winter Brothers Company
Wrentham, Massachusetts
Taps and Dies

1953
The Pep Boys—Manny, Moe & Jack
Philadelphia, Pennsylvania
Automotive Accessories

1954
Eshelman Grain, Inc.
Columbus, Ohio
Swine, Poultry and Cattle Feeds

1955
Schalk Chemical Company
Los Angeles, California
Tile Adhesive

1953
Air-Mac Incorporated of Washington
Seattle, Washington
Repair and Rental of Construction Materials

1956
Reliable Luggage, Inc.
West Pittsburgh, Pennsylvania
Suitcases, Valises and Trunks

1950
William Boyd
Beverly Hills, California
Children's Clothing

1952
Bartolomeo Pio, Inc.
Philadelphia, Pennsylvania
Wines

1956
John Cockerell, Inc.
Chicago, Illinois
Magazine Advertising and Market Research

1956
Arnold J. Fuchs
Duluth, Minnesota
Advertising and Promoting Banking Services

1954
Hollywood-Maxwell Company
Los Angeles, California
Brassieres

1957
The Kroger Company
Cincinnati, Ohio
Advertising and Promoting a Profit-Sharing
Plan

1955
Russell Kelly Office Service, Inc.
Detroit, Michigan
Equipment and Furnishings for Temporary
Offices

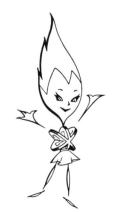

1956
Penny Therm, Inc.
Garner, Iowa
Public Utility Advertising

1954
**O & S Bearing & Manufacturing
Company**
Whitmore Lake, Michigan
Vehicle Parts

1955
Rickel Bros. Inc.
Union, New Jersey
Wooden Windows and Doors

1957
Knomark Manufacturing Company, Inc.
Brooklyn, New York
Liquid Shoe Polish

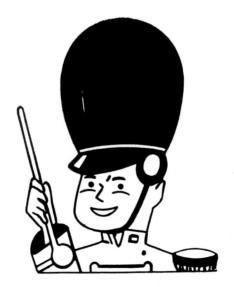

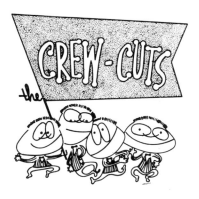

1956
Crew-Cuts, Inc.
Cleveland, Ohio
Singing and Comedy Team

1956
Medallion Enterprises
Chico, California
Hangover Tablet

1947
Baldwin Dairies, Inc.
Philadelphia, Pennsylvania
Milk and Cream

1957
Parvin Manufacturing Company
Los Angeles, California
Bar Aprons, Hats and Mitts

1954
Keuffel & Esser Company
Hoboken, New Jersey
Drafting Tools

1956
American Mail Advertising, Inc.
Canton, Massachusetts
Prepared Advertising Materials

1949
Doubleday & Company, Inc.
Garden City, New York
Books

1949
Alfred A. Anthony
New York, New York
Toys

1953
Kuehamm Foods, Inc.
Toledo, Ohio
Snack Foods

1956
McClosky Varnish Company
Philadelphia, Pennsylvania
Varnishes, Sealers and Finishes

1956
Michael J. Fadel Company
Minneapolis, Minnesota
Television Program Title

1949
Radio Merchandise Sales, Inc.
New York, New York
Television Accessories and Supplies

1957
Max Fleischer
New York, New York
Motion Pictures

1957
Globe Roofing Products, Inc.
Whiting, Indiana
Construction Materials for Insulated Siding

1945
Heinz Beverages
Pittsburgh, Pennsylvania
Non-Alcoholic, Non-Cereal, Maltless
Beverages

1944
Container Corporation of America
Chicago, Illinois
Paperboard Shipping Cartons

1953
Braunstein Freres, Inc.
New York, New York
Cigarette Paper

1945
Wynne Precision Company
Griffin, Georgia
Fishing Tackle

1949
Joe Lowe Corporation
New York, New York
Knitting Yarn and Needle Sets

1954
Medal Manufacturing Company
Sharon, Pennsylvania
Television Antennas

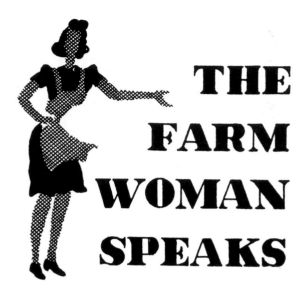

1945
Meredith Publishing Company
Des Moines, Iowa
Magazine Section

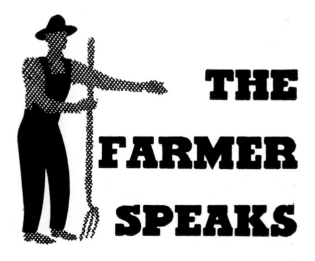

1945
Meredith Publishing Company
Des Moines, Iowa
Magazine Section

1946
Gantner & Mattern Company
San Francisco, California
Men's and Women's Swim Suits

1946
Gantner & Mattern Company
San Francisco, California
Men's and Women's Swim Suits

1945
Ludwig Scherk, Inc.
New York, New York
After-Shave Lotion

1946
Alice Frock Company
San Francisco, California
Women's and Children's Wearing Apparel

1957
Paul F. Beich Company
Bloomington, Illinois
Medicated Candy for Weight Reduction

1954
Stivers Office Service
Chicago, Illinois
Temporary Office Personnel

1947
The Advertising Research Foundation, Inc.
New York, New York
Studies, Surveys and Analyses

1946
Scott & Williams, Inc.
Strafford, New Hampshire
Hosiery for Men, Women and Children

1954
Kraft Food Company
Chicago, Illinois
Candy

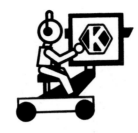

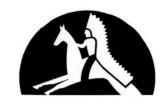

1946
Berk-Ray Corporation
New York, New York
Snow Suits, Jackets and Shirts

1946
Park Leggett Altman Company
Minneapolis, Minnesota
Adhesives

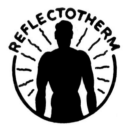

1953
Reflectotherm, Inc.
Cincinnati, Ohio
Reflective Radiant Conditioning Systems

1940
Spaulding-Moss Company
Boston, Massachusetts
Photo and Litho Prints

1953
M. Hohner, Inc.
New York, New York
Harmonicas

1947
Universal Chemical Company
Camden, New Jersey
Lighter Fluid

1946
The Euclid Underwriting Corporation
Brooklyn, New York
Candy

1953
Authentic Furniture Products, Inc.
Los Angeles, California
Milk Stools, Tables and Chairs

1951
Slik-Shav, Inc.
Detroit, Michigan
Disposable Pocket Shaving Kits

1947
Maryland Broadcasting
Baltimore, Maryland
Radio Advertising

1954
Diana Stores Corporation
New York, New York
Ladies', Misses' and Children's Clothing

1946
The Safford Company
Tryon, North Carolina
Washing Compounds

1957
Federal Stamping and Manufacturing Company
Minneapolis, Minnesota
Metal Stamping Service

1945
International Plastic Corporation
Morristown, New Jersey
Paper and Cellulose Adhesive Tapes

1957
National Rural Electric Cooperative Association
Washington, D.C.
Promotion Materials for Affiliated Companies

1947
Ely & Walker Dry Goods Company
St. Louis, Missouri
Textile Piece Goods

1950
Topper Undergarment Company, Inc.
New York, New York
Juniors' and Little Misses' Slips, Panties and Nightgowns

MR. CONTROLS

1954
Robertshaw-Fulton Controls Company
Greensburg, Pennsylvania
Main and Pilot Burner Gas Valves

1956
The Western Union Telegraph Company
New York, New York
Private Wire Communication System

With the Atomic Age upon them, American industries called on designers to refashion an image better suited to the new times. The atom and the molecule were used to represent everything from communications technology and mutual funds to gasoline and pistons. The power of the atom was a benevolent force meant to be harnessed and controlled. Forget about its primary use, the isotope was our friend. We were entering the age of precision engineering and space travel, of slide rules and rocketships — a precursor to the high tech of today. The designer used new images to fashion a vision of tomorrow. The triangle and T-square took on new meaning; along with microscopes and test tubes, forceps and micrometers, they were the tools with which to style the future. The American public, eager to embrace these new symbols, was not to be disappointed, and designers delivered with verve and gusto.

1956
New Rochelle Manufacturing Company
New Rochelle, New York
Piston Pumps

1957
Schulmerich Carillons, Inc.
Sellersville, Pennsylvania
Electric Bells and Chimes

1957
Atomic Development Mutual Fund, Inc.
Washington, D.C.
Mutual Funds Investments for Atomic Science
Companies

1956
Cleveland Institute of Radio Electronics
Cleveland, Ohio
Pamphlets, Books and Other Publications

1958
Automation Institute of America, Inc.
San Francisco, California
Classroom Instruction Courses in Business
Automation

1955
Dan Cu Chemical Company
Oklahoma City, Oklahoma
Transparent Protective Coating for Jewelry,
Optics and Mirrors

1953
L.H. Kellog Chemical Company
Minneapolis, Minnesota
Embalming Chemicals and Disinfectants

1953
L.H. Kellog Chemical Company
Minneapolis, Minnesota
Embalming Chemicals

1955
Henry Strauss & Company, Inc.
New York, New York
Sales Promotion Booklets, Reports and
Posters

1957
Turco Products, Inc.
Los Angeles, California
Organic Polymer and Non-Aqueous Solvent
Used as a Protective Coating

1956
Hycon Electronics, Inc.
Pasadena, California
Test Equipment for Televisions

1954
The Standard Oil Company
Cleveland, Ohio
Gasoline

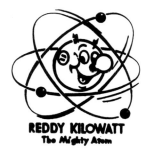

1956
Reddy Kilowatt, Inc.
New York, New York
Circulars and Advertising Matter

1953
Robotron Corporation
Detroit, Michigan
Electrical Timing and Contacting Apparatus

1957
Micro-Master, Inc.
Kansas City, Missouri
Photographic Developing Sinks and Tanks

1956
Growler Alarm Corporation
New York, New York
Electrical Fire and Police Burglar Alarm

1957
Escambia Chemical Corporation
Pensacola, Florida
Fertilizer

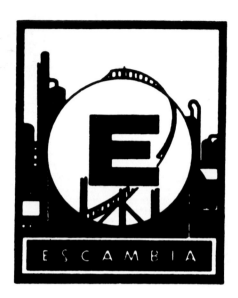

1953
Isotope Products Limited
Oakville, Ontario, Canada
Devices for Detecting Radiation

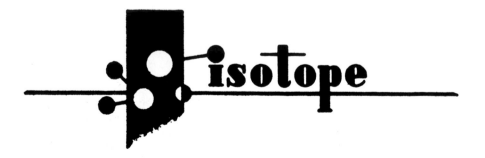

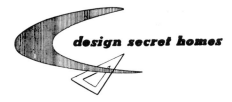

1955
Original Designs Limited
Honolulu, Hawaii
Design and Construction of Residential
Buildings

1956
Lockheed Aircraft Corporation
Burbank, California
Airplanes and Components Thereof

1956
Chrysler Corporation
Highland Park, Michigan
Motor Vehicles and Their Structural Parts

1957
Manson Laboratories, Inc.
Stamford, Connecticut
Devices to Measure Frequencies

1957
The Zeller Corporation
Defiance, Ohio
Aircraft Repair

1955
Benson-Lehner Corporation
Los Angeles, California
Equipment to Translate Various Data

1946
North American Phillips Company, Inc.
Dobbs Ferry, New York
X-Ray Apparatus for Inspection Tests and Lab
Experiments

1948
Pasadena Research, Inc.
Pasadena, California
Vitamins and Pharmaceuticals

1956
Burtel Corporation
Redwood City, California
Forceps

1956
**Fairchild Engine and Airplane
Corporation**
Costa Mesa, California
Resistance Bridge Indicators and Balances

1947
Cleveland Institute of Radio Electronics
Cleveland, Ohio
School Publications on Radio Electronics

1955
Kingston Electronic Corporation
Cambridge, Massachusetts
Absorption Analyzers

1953
Medical Management Control
San Francisco, California
Bookkeeping, Accounting and General Office
Forms and Ledgers

1955
Hirestra Laboratories, Inc.
New York, New York
Skin Lotion

1956
Chemionics Engineering Laboratories, Inc.
Wilmington, North Carolina
Copper Naphthenate Wood Preservative

1957
Hess & Clark, Inc.
Ashland, Ohio
Poultry, Stock and Veterinary Remedies and
Medicated Feed Concentrates

1954
Blaupunkt Electronik GmbH
Berlin-Wimersdorf, West Germany
Phonographs, Dictating Machines and Sound
Recording Machines

1956
United Catalog Publishers, Inc.
New York, New York
Publications on Electronics

1947
Adams and Powell, Inc.
New York, New York
General Building Contracting Work

1948
Pacific Gas Corporation
New York, New York
Butane and Propane Gases

1949
The J.M. Fink Company, Inc.
New York, New York
Designing and Installing Air-Conditioning,
Heating and Refrigeration Systems

1954
Precisionwood
Auburn, Massachusetts
Synthetic Wood Produced in Sheet Form

1947
Perfect Circle Corporation
Hagerstown, Indiana
Plastic Gauging Material

1952
**Industrial Engineering Drafting
Company**
Brooklyn, New York
Drawing Industrial Maps to Specification

1957
Temptron, Inc.
Columbus, Ohio
Furnaces

1953
Whittaker Guernsey Studio, Inc.
Chicago, Illinois
Preparation of Artwork and Advertising
Materials

1945
Worthington Products Company
Arlington, Virginia
Insecticides

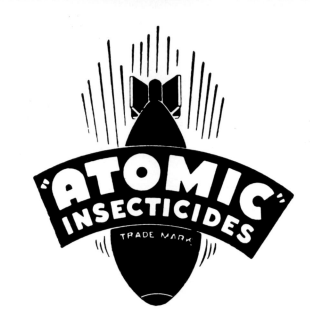

1953
Major Distributing Company
Salinas, California
Fresh Carrots

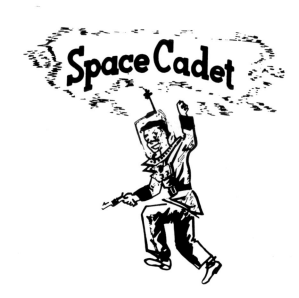

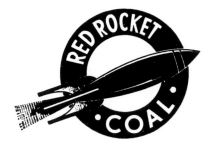

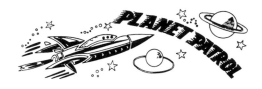

1953
Rocket Coal Company
Barbourville, Kentucky
Bituminous Coal

1955
S. Goldberg & Company, Inc.
Hackensack, New Jersey
House Slippers for Men, Women and Children

1952
Space Stamps Company
New York, New York
Pictorial Novelty Stamps

1950
Price Battery Corporation
Hamburg, Pennsylvania
Storage Batteries

1955
Harold J. Barnes
New York, New York
Space Detective Game

1947
Good Luck Glove Company
Carbondale, Illinois
Work Glove Made of Leather and Cotton
Flannel

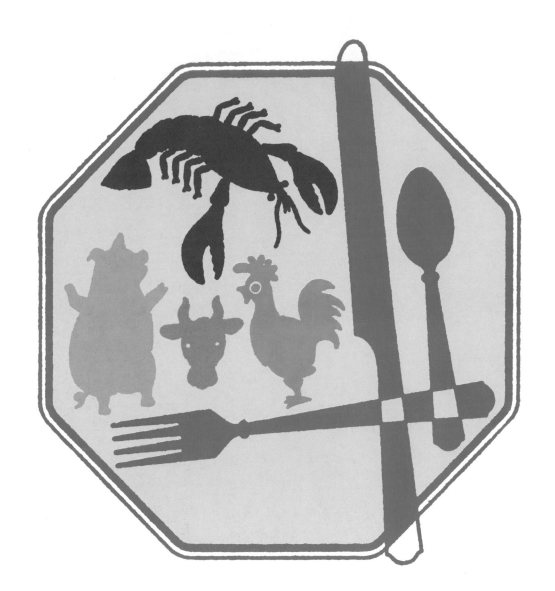

1955
Marathon Corporation
Menasha, Wisconsin
Cartons for Packaging Cooked Foods

Let's Eat

An irresistible phenomenon was occurring in America. The ethnic foods our parents and grandparents brought with them from overseas were now being assimilated, homogenized, and synthesized into the mainstream. The local corner market was disappearing and in its place came the super market.

Our choices became virtually limitless, and eating became a pastime. Drive-ins sprouted up in every town across America. Families planned barbecues in the backyard or picnics out at the lake. From soda pop to french fries, fast food became a mark of our lifestyle. The image of the chef on the label meant that the food was delicious and done to perfection. Your local grocer was fat and friendly, certifying good taste. Fish sausages sang out from the frozen foods section. And service was always with a smile.

MAR-TUNIES

1952
Dormeyer Corporation
Chicago, Illinois
Electrically Operated Deep Fat Fryers

1951
Piggly Wiggly Corporation
Jacksonville, Florida
Meats, Fruits, Vegetables, Coffee, Tea and
Candies

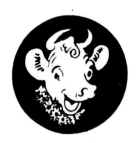

1957
Kenro Products
Lake View, Iowa
Package Including Popcorn, Bowls, Cup, Salt
Shaker and Popcorn Ball Maker

1956
Wellons Company
Dunn, North Carolina
Candy

1955
Kellogg Company
Battle Creek, Michigan
Ready-to-Eat Cereal Food

1953
Chemex Corporation
New York, New York
Coffeemakers

1957
Interstate Bakeries Corporation
Kansas City, Missouri
Bread, Rolls and Other Bakery Products

1952
The Borden Company
New York, New York
Canned, Unbaked Biscuits

1956
Real Pie Bakers
Pittsburgh, Pennsylvania
Frozen and Freshly Baked Fruit and Berry Pies

1947
Wason Brothers Company, Inc.
Seattle, Washington
Spices, Sauces and Food Flavoring Extracts

1949
Chet's Famous Foods
Eugene, Oregon
Frozen Foods Including Chicken à la King, Pot
Pies and Tamales

1948
Spaulding Bakeries, Inc.
Binghamton, New York
Bread and Bakery Products

1953
Western Chef Products, Inc.
Spokane, Washington
Compressed Sawdust Barbecue Briquettes
Fuel

1955
Kingsford Chemical Company
Iron Mountain, Michigan
Charcoal Briquettes

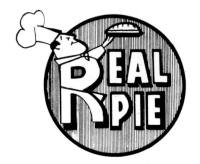

1953
Motyer & Clement Limited
London, Union of South Africa
Ginger Beer

MAR-TUNIES

1953
Tunies, Inc.
Chula Vista, California
Fish Sausages

1952
Zion Industries, Inc.
Zion, Illinois
Cookies and Cakes with Candy Fillings and
Toppings

1957
American Potato Company
Idaho Falls, Idaho
Dehydrated or Instant Potatoes

1947
Brice-Waldrop Pickle Company
Denison, Texas
Cucumber Pickles

1947
Brice-Waldrop Pickle Company
Denison, Texas
Cucumber Pickles

1949
Orange-Crush Company
Chicago, Illinois
Non-Alcoholic, Maltless Soft Drinks, Syrups,
Concentrates and Compounds

1950
Orange-Crush Company
Chicago, Illinois
Non-Alcoholic, Maltless Soft Drinks, Syrups,
Concentrates and Compounds

1945
The W.L. Maxson Corporation
New York, New York
Electric Ovens Designed Specifically for
Thawing and Cooking Frozen Food

1945
Clougherty Brothers
Vernon, California
Sausage and Other Meat Products

1954
Certified Grocers of Illinois, Inc.
Chicago, Illinois
Information Service to the Trade

1953
**Kwik-Shake Dispenser Manufacturing
Company, Inc.**
Chicago, Illinois
Mixing Unit and Dispenser for Frozen Ice
Cream Mix

1954
Red Owl Stores
Hopkins, Minnesota
Various Dry or Packaged Foodstuffs

1952
Douglas Fir Plywood Associates
Tacoma, Washington
Plywood

1954
Gold Prize Coffee Company, Inc.
Chicago, Illinois
Coffee, Tea, Dessert Toppings, Spices and
Sauces

1955
Dog N Suds, Inc.
Champaign, Illinois
Soft Drinks and Soft Drink Concentrates

1957
Wilson & Company, Inc.
Chicago, Illinois
Fresh, Cooked, Smoked, Cured and Frozen Meats

1950
Columbia Breweries, Inc.
Tacoma, Washington
Beer

1950
The Rath Packing Company
Waterloo, Iowa
Bacon

1956
The Rath Packing Company
Waterloo, Iowa
Packaged Meats

1952
Paxton and Gallagher Company
Omaha, Nebreska
Coffee

1956
Krisp-Pak, Inc.
New York, New York
Soup Mix, Cole Slaw and Collard Greens

1940
King Novelty Company
Chicago, Illinois
Paints and Painters' Materials

From the Playboy Bunny to Mickey Mouse, animals continued to be a rich source of imagery. Designers, and more particularly clients, chose to represent their products and services

Early Bird

with the charm, tenacity, or strength of certain animals. Whatever the characteristics of a particular animal or fish, they could be used or adapted to suit the needs of the product or service. Birds flew the American skies selling everything from newspapers to fertilizers. There were "Thunderbirds," "AquaDuks," and "Pe-li-cons," touting this product or that. The design styles of these animals ranged from ridiculous to "kool" and elegant. We see marks that foreshadow the trademarks of today alongside the more naive styles of the twenties and thirties. Today most of these marks have been set free or sent back to the barnyard, while a few continue to thrive.

1956
Richter Company, Inc.
New York, New York
Candles

1955
Manuel Ortiz, Jr.
Sarasota, Florida
Radios, Phonographs and Recording Sound
Amplifiers

1955
Spartan Mills
Spartanburg, South Carolina
Kitchen Towels, Tablecloths, Napkins and
Place Mats

1956
Dansk Designs, Inc.
Great Neck, New York
Steel Flatware

1953
The Gummed Products Company
Toledo, Ohio
Heat Seal Papers

1951
Town & Farm Company, Inc.
Papillion, Nebraska
Radio Program Broadcasting

1946
Bear Manufacturing Company, Inc.
Chicago, Illinois
Automobile Wheels, Tools and Racks

1956
Nixalite Company of America
Davenport, Iowa
Bird and Rodent Barrier Structure

1955
J. William Horsey Corporation
Plant City, Florida
Frozen Concentrated Orange Juice

1950
Gonda Engineering Company, Inc.
Salem, Ohio
Tricycles

1958
Outboard Marine Corporation
Waukegan, Illinois
Outboard Motors and Repair Parts

1949
Eagle Lock Company
Terryville, Kansas
Door Closers

1955
HMH Publishing Company, Inc.
Chicago, Illinois
Monthly Magazine

1947
Keyston Brothers
San Francisco, California
Automotive Seat Covers, Springs and Hinges

BEAR

Early Bird

Pe·li·con

1958
The M. Norton Company
Troy, New York
Pressure-Sensitive Adhesive Tapes

1950
Behr-Manning Corporation
Troy, New York
Adhesives

1947
Armour & Company
Chicago, Illinois
Fertilizer

1950
New York Herald Tribune, Inc.
New York, New York
Daily Newspaper

1944
The Fishery Council
New York, New York
Fresh, Canned, Frozen, Shredded, Salted,
Dried and Pickled Fish

1956
Container Corporation of America
Chicago, Illinois
Paperboard Shipping Containers with a
Flexible Liquid-Tight Bag

1956
Screen Directors Guild of America
Hollywood, California
Entertainment Services

1954
Richfield Oil Corporation
New York, New York
Gasoline, Oil and Greases

1948
Bell & Zoller Coal Company
Chicago, Illinois
Coal

1950
The Rath Packing Company
Waterloo, Iowa
Dressed Young Turkeys, Chickens and Fowl

1940
Welch Fruit Products Company
Chicago, Illinois
Non-Alcoholic, Non-Cereal, Maltless
Beverages

1952
The Reardon Company
St. Louis County, Missouri
Joint Cement, Patching Plaster, Tile Cement
Putty and Spackling

1954
Glovecraft, Inc.
Johnstown, New York
Men's Leather Jackets

1949
American Bank Note Company
New York, New York
Intaglio, Lithography, Embossing and Printing
Services

1956
Nichols Poultry Farm, Inc.
Kingston, New Hampshire
Hatching Eggs and Day-Old Chicks

1951
Mathieson Chemical Corporation
Baltimore, Maryland
Insecticides

1948
North Carolina Finishing Company
Salisbury, North Carolina
Treating Textiles for Water Resistance

1957
The Howard Zink Corporation
Fremont, Ohio
Life Preserver Cushions and Jackets

1947
Norbert Jay
New York, New York
Packaging and Product Designing

1948
C.S. Williamson & Company
Orangeburg, South Carolina
Fish Stringer

1947
The Valentine Company
Seattle, Washington
Chemical Compounds for Industrial Cleaning

1957
Urban N. Patman, Inc.
Los Angeles, California
Packages Containing Individual Servings of
Fresh Beef, Lamb and Pork

1947
Ultra Slide Fastener Corporation
New York, New York
Separable Fasteners of the Slider-Controlled
Type

1957
Dri Dux Company
Lodi, New Jersey
Water- and Mildew-Repellent Coatings for
Textiles and Paper

1954

Arbie Mineral Feed Company, Inc.
Marshalltown, Iowa
Mineralized Hog Feed

1954

Piggly Wiggly Corporation
Jacksonville, Florida
Coffee, Tea, Eggs, Beans, Spices and Other
Packaged Food

1954

The Sanitary Market
Rogers City, Michigan
Smoked Pork Loins

1958

Barbeque Queen Food Systems
Los Angeles, California
Barbeque Sauce and Salad Dressing

1956

Matco Transportation, Inc.
Brooklyn, New York
Truck Transportation Services

1958

The Burk Company
Philadelphia, Pennsylvania
Canned and Smoked Meats and Lard

1955
Sassy Dog and Cat Food Company
Long Beach, California
Cat and Dog Food

1958
Walt Disney Music Company
Burbank, California
Phonograph Records

1947
Cat's Paw Rubber Company, Inc.
Men's, Women's and Children's Rubber-Sole
Shoes

1946
Chicopee Sales Corporation
New York, New York
Cotton Piece Goods

1953
Victor Vending Corporation
Chicago, Illinois
Merchandise Vending Machines

While the circle and rectangle were still the prominent marks of the forties and fifties, designers also began to use a new palette of shapes and devices. Both literally and figuratively they drew upon the events and styles of the day. Boom-erangs, trapezoids, parallelograms, globes, crowns, and pyramids were all called into action. The NBC xylophone visually represented the network's audio signature with a mark that spoke to our inner ear. It was a time of

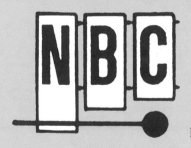

Little League Baseball and Ding-Dong School, of Mom and Pop and Bud and Sis, and every night television delivered this vision to more and more homes. It told you which car to drive and which paper towel was more absorbent, and it showed you what family life was all about. These new marks were a reflection of the Great American Dream.

1948
The Cleveland Gypsum Co.
Cleveland, Ohio
Mill Mix Plasters and Mortars

1949
Lien Chemical Company
Franklin Park, Illinois
Insecticide Powders and Household
Disinfectants

1952
Mueller Welt, Inc.
Chicago, Illinois
Contact Lenses

1953
Menasco Manufacturing Company
Burbank, California
Aircraft Landing Gear

1956
Beebe Brothers
Seattle, Washington
Winches

1948
Timely Toys, Inc.
St. Louis, Missouri
Toy Mechanical Automobiles

1947
Robert Gair Company
New York, New York
Folding Paperboard Cartons and Corrugated
Fibreboard Shipping Boxes

1949
Kuster Laboratories, Inc.
San Francisco, California
Food Seasoning Powder, Whose Principal
Ingredient Is Monosodium Glutamate

1951
Decca Records, Inc.
New York, New York
Grooved Phonograph Records

1943
William R. Warner & Company
New York, New York
Medicinal Preparations Indicated in the
Treatment of Constipation, Neuralgia and
Headaches.

1957
Schultz & Hirsch Company
Chicago, Illinois
Mattresses and Box Springs

1942
The Baltimore & Ohio Company
Baltimore, Maryland
Railroad Passenger and Transportation Service

1954
Cleaver-Brooks Company
Milwaukee, Wisconsin
Stills and Parts Thereof

1947
North Carolina Finishing Co.
Raleigh, North Carolina
Starches, Waxes and Other Water Resistant
Materials Used in Textiles and Fabrics

1949
Fairmount Tool and Forging
Cleveland, Ohio
Hand Tools, Punches, Dolly Blocks and Body
Spoons

1957
Presidential Homes, Inc.
Pemberton, New Jersey
Prefabricated Buildings and Parts Thereof

1947
Water Service Laboratories, Inc.
New York, New York
Chemical Treatment of Domestic Water

1940
Standard Oil Company of California
San Francisco, California
Gasoline, Lubricating Oils and Greases

1948
Michel & Pfeffer Iron Works, Inc.
San Francisco, California
Structural Parts for Steel Buildings

1954

Potato Specialties, Inc.
Chicago, Illinois
Fresh Potatoes and Onions

1947

Continental Basic Materials Corporation
Chula Vista, California
Aggregate of Expanded Perlite

1956

Oris Watch Company, Limited
Holstein, Switzerland
Watches, Clocks, Dials and Cases

1956

General Motors Corporation
Detroit, Michigan
Washing, Drying and Ironing Machines

1953

The Garrett Corporation
Los Angeles, California
Air-Conditioning and Refrigeration

1953

Grant Pulley & Hardware Corporation
Flushing, New York
Mounting Hardware for Doors and Windows

1940
The Emerson Electric Manufacturing Company
St. Louis, Missouri
Electric Motor Controls

1949
Electronics Systems Corporation
Kansas City, Missouri
Diminutive Radio Receiving Sets

1940
Roux Distributing Company
New York, New York
Hair Colorings, Shampoos, Tints, Bleach and Bluing

1949
Cadillac Stamp Company
Detroit, Michigan
Steel Stamps, Embossing and Marking Dies and Machines

1958
Saltzson Drapery Company
Philadelphia, Pennsylvania
Furniture Slip Covers

1949
The Northwest Public Power Association
Vancouver, Washington
Informational Services to Its Subscribing Publicly Owned Electric Utilities

1947

West Point Hosiery Company
West Point, Pennsylvania
Women's Hosiery

1947

American Colloid Company
Chicago, Illinois
Bentonite Clays

1955

Devry Technical Institute, Inc.
Chicago, Illinois
Electronic Circuit Components

1945

E.L. Mustee & Sons
Cleveland, Ohio
Gas Water Heaters

1954

Waldorf Paper Products Company
St. Paul, Minnesota
Corrugated Paper Board

1946

Delta Color Corporation
New York, New York
Ready-Mixed Waterbase Show Card Color

1940
RKO Pictures
New York, New York
Recorded Sounds and Images on Films
Adapted for Reproduction

1945
Brown & Bigelow
St. Paul, Minnesota
Large and Small Leather Goods

1940
Columbia Broadcasting System, Inc.
New York, New York
Phonograph Records

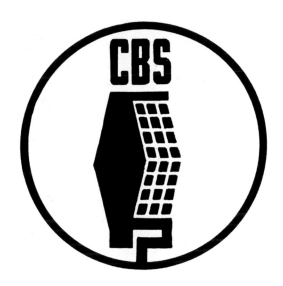

1956
Columbia Broadcasting System, Inc.
New York, New York
Mechanically Grooved Phonograph Records

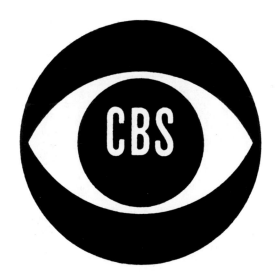

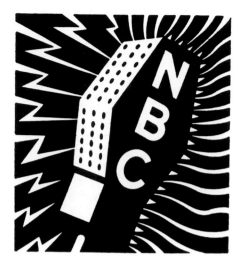

1947
National Broadcasting Company, Inc.
New York, New York
Radio Sound Broadcasting and Recorded
Radio Programs

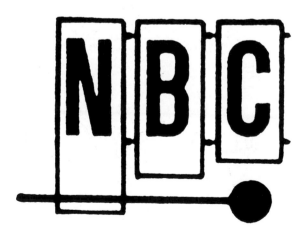

1954
National Broadcasting Company, Inc.
New York, New York
Radio Sound Broadcasting and Recorded
Radio Programs

1948
Corning Glass Works
Corning, New York
Glass and Ceramics

1956
John C. Virden Company
Cleveland, Ohio
Electric Lighting Fixtures

1948
Thonet Brothers, Inc.
New York, New York
Chairs, Stools, Sofas and Tables

1947
Coach & Car Equipment Corporation
Chicago, Illinois
Railway Coach Seats

1946
Tips Magazine, Inc.
New York, New York
Weekly Periodical

1945
**Metropolitan Watch Material Importing
Company**
New York, New York
Watch Findings, Movements and Parts Thereof

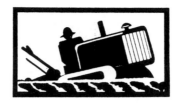

1942
Shook Bronze Corporation
Lima, Ohio
Bushing Metals

1947
Tractor Training Service
Portland, Oregon
Booklets, Pamphlets and Leaflets

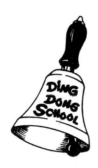

1947
Western Tablet & Stationery Corporation
Dayton, Ohio
Paper Tablets and Envelopes

1953
National Broadcasting Company, Inc.
New York, New York
Children's Outer T-Shirts

1946
Atlas Instrument Company
Haddonfield, New Jersey
Electric Scissors

1947
R.T. French Company
Rochester, New York
Laundry Bluing

1951
Fred W. Albertson
Washington, D.C.
Radio and Wire Teletypewriters

1953
Signode Steel Straping Company
Chicago, Illinois
Load Retaining Doors

1956
Borg-Warner Corporation
Chicago, Illinois
Overdrives, Brakes and Parts Thereof

1940
Schering & Glatz, Inc.
Bloomfield, New Jersey
Rectal Suppositories

1957
Pan American World Airways, Inc.
New York, New York
Transportation of Freight and Passengers
by Air

1946
Murray Silverstein
Brooklyn, New York
Ladies' Undergarments

1957
J. Warren Bowman
St. Petersburg, Florida
Snacks Formed of Grain and Other Materials

1958
Moore's Time-Saving Equipment, Inc.
Indianapolis, Indiana
Rug-Cleaning Equipment

1948
Louis G. Cowan, Inc.
New York, New York
Radio Program Series on Mystery Dramas

1955
Whitin Machine Works
Whitinsville, Massachusetts
Direct-Image Paper Plates for Offset
Duplication

1948
W.W. MacGruder, Inc.
Denver. Colorado
Passenger Airline Transportation

1957
Personal Shoe Company
Haverhill, Massachusetts
Molding Kits for Shoes

1949
Capitol Records, Inc.
Los Angeles, California
Grooved Phonograph Records

1940
Dome Chemicals, Inc.
New York, New York
Tablets for Forming Burroughs Solution

1958
F. W. Dodge Corporation
New York, New York
Books, Catalogs, Magazines and Other
Publications

1949
Permanent Cement Company
Oakland, California
Cement and Processed Lime

1954
Herbert Kronish
Beverly Hills, California
Construction of Homes

1954
Sears, Roebuck & Company
Chicago, Illinois
Household Brackets, Holders, Edges and Rims

1948
The M. Werk Company
St. Bernard, Ohio
Soap

1954
Sam Zakim
Paterson, New Jersey
One-Coat Flat Enamel Paint

1953
Little League Baseball
New York, New York
Young Boys' T-Shirts and Sweatshirts

1950
Stanley Home Products, Inc.
Westfield, Massachusetts
Tooth Powders, Pastes, Bath Lotions and
Creams

1957
College Club Program, Inc.
Brookline, Massachusetts
Savings Account Services

1957
Pillsbury Mills, Inc.
Minneapolis, Minnesota
Flour, Refrigerated Doughs for Cookies, Cakes,
Waffles and Pancakes

1956
A. Melchior & Company
Hamburg, West Germany
Table and Bed Linens, Textile Carpets and
Fabrics

1954
McGraw-Hill Book Company, Inc.
New York, New York
Fountain Pens

1951
Rockwell Manufacturing Company
Pittsburgh, Pennsylvania
Securing Adhesives

1940
Joseph Burnett Company
Boston, Massachusetts
Pastes, Liquids for Color Food Products

1947
Prestile Manufacturing Company
Chicago, Illinois
Synthetic Adhesive Cements in Liquid or Solid
Form

1946
Silvray Company, Inc,
New York, New York
Electric Lamps

1940
Woodruff Beverages
Los Angeles, California
Sparkling Water

1952
Serta Associates, Inc.
Wilmington, Delaware
Mattresses

1951
Wally Shulan & Company
New York, New York
Household Detergent

1955
Royal Manufacturing Company, Inc.
Prescott, Arizona
Plastic Bottles and Jars

1954
Trans-Sphere Trading Corporation
Mobile, Alabama
Peat Moss

1952
Volvo
Chicago, Illinois
Gas, Oil and Other Automotive Products

1940
The Sherwin-Williams Company
Cleveland, Ohio
Paints, Enamels, Lacquers, Fillers and
Pigments

1946
Apex Industries, Inc.
New York, New York
Radio and Television Receiving Sets and
Electric Phonographs

1956
Kiekhaefer Corporation
Cedarburg, Wisconsin
Oil

1956
Kaye-Halbert Corporation
Culver City, California
Radio Receiving Sets

1957
Crown Zellerbach Corporation
San Francisco, California
Towel-Dispensing Cabinets

1954
Coachcraft, Limited
Hollywood, California
Automobile Air-Conditioners and Luggage
Carriers

1952
Shure Brothers, Inc.
Chicago, Illinois
Piezoelectric Instruments to Measure and
Analyze Vibrations

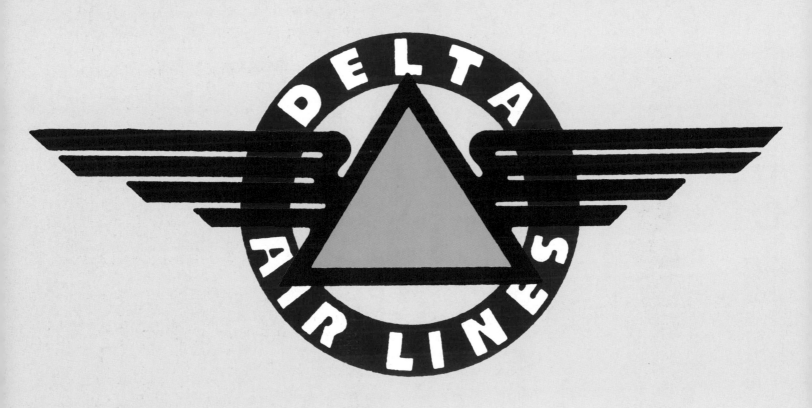

1947
Delta Air Lines, Inc.
Atlanta, Georgia
Air Transportation of Passengers, Mail and
Express

Man's eyes were aimed at the skies during the forties and fifties. Rockets were launched and the Atomic Age gave way to the Space Age. Viking golf balls soared well into the stratosphere, guaranteeing the golfer a booming drive off the tee. The wings of a bird became the emblem of travel, implying swiftness, motion, and freedom from danger. The Standard Oil Company's trademark for its product RPM, suggested speed with both image and type. Naturally, commercial airlines all carried winged motifs as their trademark. The sleek, streamlined image meant that you would be at your destination "in no time flat." America was on the move, fulfilling its desire to travel and expanding on its notion of freedom. Transportation, as it was illustrated in the company trademark, implied to the consumer a spirit of continuous motion, speed, and flight.

1948
Nogero Manufacturing Company
Portland, Oregon
Detergent and Non-Abrasive Cleaning
Preparation

1940
Cosby-Hodges Milling Company, Inc.
Birmingham, Alabama
Plain and Self-Rising Wheat Flour

1956
Western Airlines, Inc.
Los Angeles, California
Transportation of Passengers, Mail and
Express

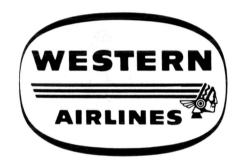

1955
Viking Sports Products, Inc.
Englewood, New Jersey
Golf Balls

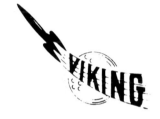

1946
Ford Motor Company
Dearborn, Michigan
Motorcars

1957
Schaper Manufacturing Company, Inc.
Minneapolis, Minnesota
Game and Game Apparatus

1954
Consolidated Bus Lines
Bluefield, West Virginia
Bus Transportation Service

1948
Airway Fruit & Vegetable Company, Inc.
Baltimore, Maryland
Fresh Vegetables

1948
Eastern Air Lines, Inc.
New York, New York
Air Transportation of Persons, Property and Mail

1946
The American Oil Company
Baltimore, Maryland
Tires, Tubes, Fan Belts and Repair Kits for Same

1951
Truck Transport Company
Detroit, Michigan
Transporting Goods by Motor Vehicles

1946
Continental Aviation and Engineering Corporation
Detroit, Michigan
Airplane Propellers and Parts Thereof

1948
American Airlines, Inc.
New York, New York
Air Transport of Passengers and Freight

1947
Standard Oil Company of California
San Francisco, California
Rust Preventatives and Inhibitors

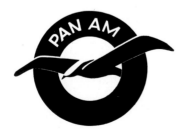

1955
Delta Air Lines, Inc.
Atlanta, Georgia
Transportation of Passengers, Mail and Express

1947
Wesel Manufacturing Company
Scranton, Pennsylvania
Beveling, Routing, Sawing and Trimming Machines for Printing

1947
Cornell Research Foundation
Buffalo, New York
Models for Comparison and Study for Technical Use

1958
Northrop Aircraft, Inc.
Beverly Hills, California
Manned Aircraft, Missiles and Drones

1947
The American Oil Company
Baltimore, Maryland
Gasoline

1940
The Stouse Adler Company
New York, New York
Men's Undergarments

1956
Delta Air Lines, Inc.
Atlanta, Georgia
Transportation of Passengers, Mail and
Express

1951
Piasecki Helicopter Corporation
Morton, Pennsylvania
Helicopters

1947
Lockheed Aircraft Corporation
Burbank, California
Airplanes and Structural Parts Thereof

1954
North Central Airlines, Inc.
Minneapolis, Minnesota
Air Transportation of Persons, Property and
Mail

1946
Republic Aviation Corporation
Farmingdale, New York
Airplanes and Parts Thereof

1946
Bell Aircraft Corporation
Wheatfield, New York
Helicopters and Structural Parts Thereof

1955
North American Aviation, Inc.
Los Angeles, California
Rocket Engines and Components Thereof

1956
Standard Oil Company of California
San Francisco, California
Cleaning Compounds for Household,
Professional and Commercial Use

Elephant Hide

1953
J.W. Zanders Feinpapierfabrik
Gladbeck, West Germany
Parchment Paper and Paperboards

From German photographic papers to Argentinian shoes, America's buying power was increasing. One by-product of World War II was the growth of world commerce. Import and export businesses were on the rise. American designers were being influenced by their European counterparts, and foreign trademarks were readily seen in the American business sector. A foreign mark was distinctive. More times than not the message was graphic and unidirectional. In the trademark for Koenig & Bauer, a German manufacturer of printing presses, one senses a simplicity and exactness. The stitching on the "N" for Necchi, an Italian maker of sewing machines, accurately portrays what that company had to offer. Most of these marks, unembellished in nature, have a folk quality about them; they succinctly state their purpose and origin. Only in London, England, would the stark silhouette of a man with an umbrella, braced against the rain, be chosen to represent candy lozenges for coughs and colds.

1954
Hakato Vinegar Company
Handa-Shi, Japan
Vinegar

1949
Vantona Textiles Limited
Manchester, England
Bed Coverlets, Sheeting, Bedspreads, Curtains
and Towels

1956
Schnellpresesenfabrik Koenig & Bauer
Aktiengesellschaft
Würzburg, West Germany
Printing Presses and Graphic and Stereotyping
Machinery

1953
Kaltenbach und Voigt
Biberach-Riss, West Germany
Dental Drilling Machines

1957
Agfa Aktiengesellschaft fär
Photofabrikation
Bayerwerk, West Germany
Light-Sensitive Photographic Papers

1949
The Mountain Copper Company, Limited
London, England
Copper Sulfate, Carbonate, Hydroxide, Iron
Oxide and Pyrites

1945
Tonsa, Sociedad Anonima Comercial E
Industrial
Buenos Aires, Argentina
Shoes, Galoshes, Half-Boots, Pumps and
Slippers

1954
Gustav August Seewer
Burgdorf, Switzerland
Power Operated Roller-Type Machines for
Paper

1955
Zavody V.I. Lenina Plzen, Narodm Podnik
Plzen, Czechoslovakia
Electric Motors, Transformers and Condensers

1954
Frymann and Fletcher Limited
Nottingham, England
Piece Goods of Silk, Cotton, Wool and
Worsted Fibers

1957
Gemsebau A.G. Tagerwilen
Tagerwilen, Switzerland
Vegetable Juice

1952
System Trachtenberg
Zurich, Switzerland
Leaflets and Textbooks

1949
Sewing Silks, Limited
Middlesex, England
Woolen Knitting Yarns

1954
Alfred Sternjakob K.G.
Frankenthal, West Germany
Extendable Multi-Purpose Bags and Valises

1953
Klockner-Humboldt-Deuts
Aktiengesellschaft
Koln-Deutz, West Germany
Trucks, Buses, Ambulances and Refuse-
Collecting Vehicles

1954
S.A. Eteco Company
Zweregem, Belgium
Barbed Wires and Fencing

1944
Calzado Domit, S.A.
Mexico City, Mexico
Leather, Fabric and Rubber Shoes

1953
Ornulf Thorbjorn Myklestad
Oslo, Norway
Hard Bread and Alga Flour

1950
Linea Aeropostal Venezolana
Caracas, Venezuela
Air Transportation of Persons and Property

1953
Mirna, Poduzece Za Preradbu Ribe
Rijeka, Yugoslavia
Canned Fish

1954
Everest Nahmaschinen
Stuttgart, West Germany
Sewing Machines and Parts Thereof

1953
Zellstollfabrik Waldhof
Mannheim, West Germany
Pulp Paper and Paper Products

1957
"Nordsee" Deutsche Hochseefischerer Aktiengesellschaft
Bremerhaven, West Germany
Fresh, Fried, Smoked, Frozen and Preserved Fish

1956
"Nordsee" Deutsche Hochseefischerer Aktiengesellschaft
Bremerhaven, West Germany
Fresh, Fried, Smoked, Frozen and Preserved Fish

DEUTSCHE

LUFTHANSA

1945
Adolph Saurer Company
Arbon, Switzerland
Automobiles, Wheels, Bodies and Transmissions

1955
Deutsche Lufthansa Aktiengesellschaft
Koln, West Germany
Air Transportation of Persons, Property and Mail

1944
Lennard Lee Narvill & Company, Limited
Yorkshire, England
Perfumery, Shampoo, Creams and Other Hair Treatments

1953
Horlicks Limited
Slough, England
Medicinal Preparations for Colds, Headaches, Neuralgia and Indigestion

1953
Mardesic Tvornic Ribljih Konservi
Zadar, Yugoslavia
Canned Fish

1952
Vittoria Necchi Società per Azioni
Pavia, Italy
Sewing Machines

1950
Naphtol Chemie Offenbach
Offenbach am Main, West Germany
Fur Dyes and Dyestuffs

1948
Gunther Wagner, S.R.L.
Buenos Aires, Argentina
Writing and Drawing Inks

1950
Syndicat Français
Paris, France
Tuxedos, Underwear and Evening Wear

1950
Syndicat Français
Paris, France
Tuxedos, Underwear and Evening Wear

1948
Avalon Leather Board Company, Limited
Street, England
Cellulose Fibres for Use as a Leather
Substitute

1955
Ciba Limited
Basel, Switzerland
Textile Auxiliary Agents

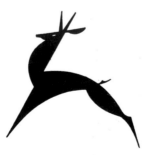

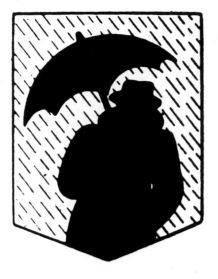

1952
Rowntree and Company
London, England
Medicinal Candy Lozenges

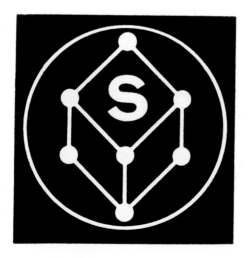

1957
Institut Dr. Ing. Reinhard Straumann
Waldenburg
Basel-Campagne, Switzerland
Parts for Clocks and Watches

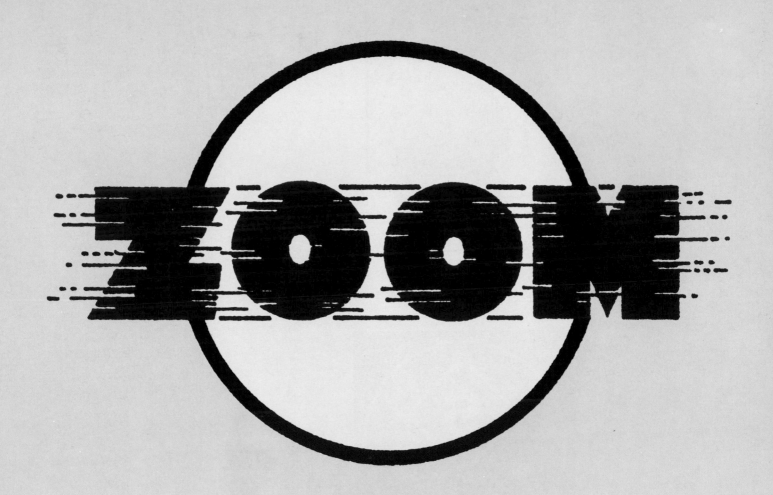

1945
Danbett Products Company
Hawthorne, California
Crystal Cleaning Preparation for Rugs,
Upholstery, Furniture and Clothing

The arrangement of letterforms was a way of telling you more about the product — it was fast, strong, and bold, or it was modern, tasteful, and in-step. The style of the type told you these products were *Super* or *Tip-Top* or *Fab.* Whether the product was soap or sunglasses, each had a distinctive manner of identifying itself. Some are silly, some are elegant, and some are a little of both. The range of typographic styles reflects the many personalities and identities of American business. Brand identification was not yet monitored by focus groups and lengthy consumer studies. Business and industry were more cavalier in their choice of product identity as we can see with such names as Aristokraft, Bank-A-Count, Sophisti-Cat, and others. Today we may snicker at these names, but they bring back fond memories of a simpler, less controlled period of American design.

1953
American Envelope Company
West Carrollton, Ohio
Commercial, Window and Catalog Envelopes

1946
Marjory W. Gandelman
New Haven, Connecticut
Picture Writing Paper and Envelopes

1951
Sears Roebuck & Company
Chicago, Illinois
Watches, Movements, Cases and Parts Thereof

1956
Arabesque, Inc.
Chicago, Illinois
Plaques

1954
Lido Frozen Foods, Inc.
Little Rock, Arkansas
Pre-Cooked Frozen Soups, Poultry, Vegetables
and Yams

1955
Beauty Counselors, Inc.
Grosse Pointe, Michigan
Hand Cleanser and Soap

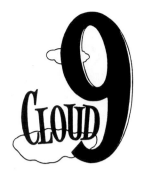

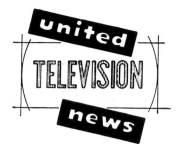

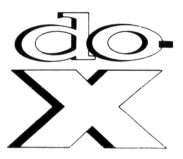

1958
L-J Enterprises, Inc.
Boulder, Colorado
General Chemical Cleaning Preparations

1952
United Press Associations
New York, New York
Distributing Motion Picture Films, Still
Pictures, Charts, Maps and Other Visuals

1957
Schalk Chemical Company
Los Angeles, California
General Cleaner for Washable Surfaces

1954
Union Bag & Paper Corporation
New York, New York
Semi-Chemical Corrugating Medium

1955
Eska Company
Dubuque, Iowa
Scale Model Miniature Tractors, Hay Loaders,
Crawlers, Wagons and Plows

1957
The Estimatic Corporation
Denver, Colorado
Estimating Services for Contractors

1954
Power Glo Products
Queens Village, New York
Golf Club Refinishing and Cleaning Kits

1957
Arranbee Doll Company, Inc.
Hicksville, New York
Dolls and Doll Accessories

1955
Keeshan-Miller Enterprises
New York, New York
Title for Televison Show Featuring Puppets,
Story Telling and Farm Animals

1954
United Co-operatives, Inc.
Alliance, Ohio
Ready-Mixed Paints

1956
The Proctor & Gamble Company
Cincinnati, Ohio
Home Permanent-Waving Kits

1957
Dow Corning Corporation
Midland, Michigan
Organopolysiloxane Fluids for Use as Polishes
and Polish Ingredients

1955
Washington Aluminum Company, Inc.
Baltimore, Maryland
Gangways, Shiftable Steps and Hatch Covers

1957
Bank-A-Count Corporation
Wisconsin Rapids, Wisconsin
Machine Tabulating Financial Record Keeping
Service for Bank Depositors

1948
Colgate-Palmolive-Peet Company
Jersey City, New Jersey
Soaps for Laundry and Household Use

1946
McNeill and McNeill
Los Angeles, California
Tablecloths, Window Curtains and Towels

1950
Arrow Manufacturing Company
West New York, New Jersey
Plastic Cases Designed for Holding Watches

1945
Queen City Cutlery Company
Titusville, Pennsylvania
Pen Knives, Shears and Kitchen Knives

1954
Bowlerama, Inc.
Minneapolis, Minnesota
Promoting the Business of Bowling Alley
Operations

1946
Virginia Demoro
Riverside, New York
Skin Lotions

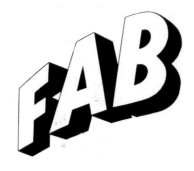

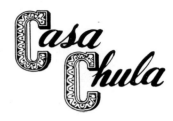

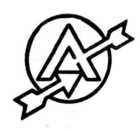

1949
The Old Joe Distillery Co.
Lawrenceburg, Kentucky
Whiskey

1945
Gray-Mills Company
Evanston, Illinois
Refrigerating Apparatus

1946
The Green Company, Inc.
Kansas City, Missouri
Jewelry and Personal Wear

1946
Westelectric Castings, Inc.
Los Angeles, California
Steel Castings

1954
Lakeland Engineering Associates, Inc.
Lakeland, Florida
Prefabricated Structural Concrete Beams,
Columns and Wall Panels

1947
Ernest H. Vanderwall Company
San Francisco, California
Lathe Center

1953
The Frito Company
Dallas, Texas
Canned Chili, Tamales and Tacos

1957
Schaper Manufacturing Company, Inc.
Minneapolis, Minnesota
Game and Game Apparatus

1953
Hassenfeld Brothers, Inc.
Central Falls, Rhode Island
Toy Kit Containing Figure with Plastic,
Removable Body Parts

1955
Vital Publications, Inc.
New York, New York
Cartoon Booklets

1954
Zenith Radio Corporation
Chicago, Illinois
Radio and Television Receiving Sets and Parts
Thereof

1952
Bluhil Foods, Inc.
Denver, Colorado
Salted Nuts

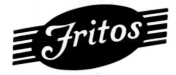

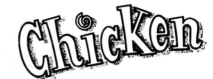

1956
Phillips Packing Company, Inc.
Cambridge, Massachusetts
Canned Soups, Vegetables and Beans

1957
The Lummus Company
New York, New York
Chemical and Petroleum Distillation, Refinery
Apparatus and Power Plant Equipment

1954
Knoll Associates, Inc.
New York, New York
Curtain and Upholstery Fabrics of Natural and
Synthetic Fibers

1950
Knoll Associates, Inc.
New York, New York
Tables, Desks, Seats, Stools, Sofas, Beds,
Chests, Cabinets and Trays

COLORAMIX

La Jolla

taffaswish

Realist

1955
Napko Paint & Varnish Works
Houston, Texas
Paints

1948
La Jolla Sportswear Company, Inc.
Los Angeles, California
Men's Trousers

1950
Greet-A-Tab Company
Baltimore, Maryland
Greeting Cards and Indicia for Greeting Cards

1955
L. Schneierson & Sons, Inc.
New York, New York
Ladies' and Children's Slips and Petticoats

1952
David White Company
Milwaukee, Wisconsin
Stereoscopic Cameras and Related Equipment

1957
Metromatic Manufacturing Company, Inc.
Medford, Massachusetts
Furnaces and Water Heaters

1955
Grace Chemical Company
New York, New York
Urea Feed Compound Used as a Substitute for
Protein

1957
Holiday Yachts, Inc.
Centerport, New York
Sailboats and Power Boats

1948
Kryptar Corporation
Rochester, New York
Photographic Film

1948
Kemart Corporation
San Francisco, California
Drawing Papers and Illustration Boards

1952
The Kerr Wire Products Company
Chicago, Illinois
Display Stands, Racks and Shelves

1954
Kenworth Motor Truck Corporation
Seattle, Washington
Motor Vehicles

ROTRON

1953
Dorse and Margolin, Inc.
Westbury, New York
High-Frequency Antennas

1954
Rotron Manufacturing Company, Inc.
Woodstock, New York
Electric Switches

1949
Hubbard and Company
Pittsburgh, Pennsylvania
Anchor Rods, Eye Bolts, Clamps, Pole Steps,
Brackets and Braces

1948
Strobo Research
Milwaukee, Wisconsin
Photographic Equipment

1953
Mid-States Corporation
Chicago, Illinois
House Trailers

1952
McGraw Electric Company
Milwaukee, Wisconsin
Electrical Conductor Connectors

1953
Ansul Chemical Company
Marinette, Wisconsin
Portable Hand and Wheel-Mounted Fire-
Extinguishers

1954
Colgate-Palmolive Company
Jersey City, New Jersey
Sudsing Cleaner, Cleanser and Detergent

1955
Tom Daly Electric, Inc.
Barberton, Ohio
Detergent for Automatic Washing Machines

1956
The Astatic Corporation
Conneaut, Ohio
Microphones for Radio and Television
Broadcasting, Recording, Public Address
Systems and Reproduction

1958
The Data Products, Inc.
Hartford, Connecticut
Printed Checks, Check Books and Bank
Stationery

1955
Inland Electronics Corporation
Aurora, Illinois
Design and Development of Electronic
Products

136

1956
Kiekhaefer Corporation
Cedarburg, Wisconsin
Oil

1955
Radiation Applications, Inc.
New York, New York
Monthly Publication

1952
Beaunit Mills, Inc.
New York, New York
Thread and Yarn

1953
Pillsbury Mills, Inc.
Minneapolis, Minnesota
Wheat Flour

1957
The Royal Manufacturing Company
Bowling Green, Ohio
Thermally Insulated Jugs and Chests

1956
Automagic Vendors, Inc.
St. Louis, Missouri
Merchandising Vending Machines

1954
The Dean Company
Canton, Ohio
Ointment for Piles and Hemorrhoids

1952
Miljam Plastic Instrument
Manufacturing Company, Inc.
Washington, D.C.
Hypodermic Syringes

1957
Fairway Foods, Inc.
St. Paul, Minnesota
Coffee

1957
Hi-Line Company, Inc.
New York, New York
Infants' and Children's Apparel

1953
Edson, Inc.
Chicago, Illinois
Draperies, Card Table Covers and Piece Goods

1954
Textile Adjuncts Corporation
Brooklyn, New York
Synthetic Resins

Armella

1954
Armtex, Inc.
Pilot Mountain, North Carolina
Knitted Textile Fabric of Cotton, Wool and
Synthetic Fibers

1957
Walt Disney Productions
Burbank, California
Television Program Title

1954
Hudson Hosiery Company
Charlotte, North Carolina
Hosiery for Women and Children

1955
The Homalite Corporation
Wilmington, Delaware
Clear Cast Plastic Sheet Material

1957
Technical Marketing Associates, Inc.
Concord, Massachusetts
Completely Integrated Marketing Services

1950
Baracuta Limited
Manchester, England
Trousers, Overcoats, Capes and Other Apparel
Items

1954
American Bosch Arma Corporation
Garden City, New York
Gyroscopes, Compasses, Stable Verticals and
Other Navigation Instruments

1956
Fabritate, Inc.
Cedar Grove, New Jersey
Flexible, Textured Wall-Covering Material

1957
W.L. Ollinghouse
Little Rock, Arkansas
Fishing Boats

1955
H.J. Justin & Sons, Inc.
Fort Worth, Texas
Boots and Shoes

1953
Askania-Werke, A.G.
Berlin-Friedenau, West Germany
Scientific and Industrial Precision Instruments

1945
Sutho Suds Company
Indianapolis, Indiana
Washing and Cleansing Compound

MAN Alive

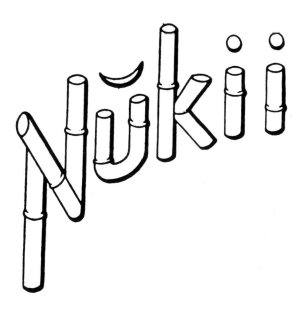

1946
Parfumerie De Raymond
New York, New York
Deodorant, After-Shave, Cologne, Talcum
Powder and Hairdressing Preparations

1952
David B. Franz
Miami Beach, Florida
Cookies

143

1953
Dallas Iron & Wire Works, Inc.
Dallas, Texas
Swings, Gliders, Gyms, Exercise Frames and
Parts Thereof

1954
Tip-Top Products Company
Omaha, Nebraska
Household Cement

1955
C.G. Mitchell, Inc.
Binghamton, New York
Pictures Contained in Tapered Frames so as to
Complement One Another

1958
Marine Plastics, Inc.
Fort Lauderdale, Florida
Boats

1949
Crown Zellerbach Corporation
San Francisco, California
Toilet Tissue

1950
Gamble-Skogmo, Inc.
Minneapolis, Minnesota
Milk Cans, Dairy Pails and Stock Tanks

1946
Electronic Rectifiers, Inc.
Indianapolis, Indiana
Electronic Rectifiers

1947
Picture Recording Company
Oconomowock, Wisconsin
Picture Reproduction Record for Use with a
Stereopticon Projector

1955
Sunbeam Corporation
Chicago, Illinois
Electric Water Kettles and Tea Brewing
Apparatus

1955
Wire Specialties Company
Santa Clara, California
Cooking Grills

1954
American Alcolac Corporation
Baltimore, Maryland
Detergents for Industrial Use

1957
Colgate-Palmolive Company
New York, New York
Sudsing Cleaner, Cleanser and Detergent

1953
Wholesale Sales Company
Wilmington, Delaware
Auto Polish

1955
Norcross, Inc.
New York, New York
Greeting Cards and Printed Greeting Folders

1956
H.F. Stimm, Inc.
Buffalo, New York
Construction and Repair of Buildings, Bridges,
Roads, Railroads and Utilities

1949
Sumner Chemical Company
Zeeland, Michigan
Chemical Compounds

1949
The Craftsman Press, Inc.
Seattle, Washington
Business Forms

1955
Pioneer Equipment Sales Company
Pasadena, California
Telephone Accessories

1955
Homasote Company
Trenton, New Jersey
Wall Board and Fibrous Material

1956
Ashland Oil & Refining Company
Ashland, Kentucky
Gasoline

1952
The Koch Engineering Company, Inc.
Wichita, Kansas
Petroleum Refinery Apparatus and Parts
Thereof

1948
Certified Dry Mat Corporation
New York, New York
Matrix, Dry Mat, or Board Used in
Stereotyping or Electrotyping

1956
Hancock Corporation
Philadelphia, Pennsylvania
Scrub Mops with Absorbent Material

1948
Reflex Impression Corporation
Glendale, New York
Inorganic Molding Powders and Compositions
for Dental Castings

1956
Hamilton Watch Company
Lancaster, Pennsylvania
Watchmaker's Tools and Parts

1955
Herman Miller Furniture Company
Zeeland, Michigan
Fabrics for Draperies and Upholstery

1949
Hall Brothers, Inc.
Kansas City, Missouri
Greeting Cards

1947
Gibson, Inc.
Kalamazoo, Michigan
Guitars, Mandolins, Violins and Banjos

1948
Toy Corporation of America
Leominster, Massachusetts
Plastic Ducks and Other Water Fowl in
Caricature Form

1956
Orenda Engines Limited
Malton, Ontario, Canada
Gas Turbine Engines and Parts Thereof

1948
Consolidated Television Corporation
New York, New York
Receiving Television and Radio Sets

1948
J & J Tool and Machine Company
Chicago, Illinois
Machines for Cutting Tubular Metal Elements

1956
Automotive Products, Inc.
Portland, Oregon
Apparatus for Testing and Analyzing Diesel
Fuel Pumps

1950
Bark Dog Food Company
Midland, Michigan
Dog Meal

1957
Safeway Stores, Inc.
Oakland, California
Laundry Starch and Household Bleach

1949
Rolo Manufacturing Company
Houston, Texas
Wellcheckers

1957
The Hoover Company
North Canton, Ohio
Dirt Collecting and Filtering Bags

1956
Foremost Dairies, Inc.
San Francisco, California
Butter, Milk, Ice Cream and Eggs

1958
Lockheed Aircraft Corporation
Burbank, California
Airplanes and Components Thereof

1957
Record Corporation of America
Union City, New Jersey
Grooved Phonograph Records

1954
Neptune Storage, Inc.
New Rochelle, New York
Services in Moving, Packing, Shipping and
Storing Household Goods

1956
Bausch & Lomb Optical Company
Rochester, New York
Sunglasses, Shooting Glasses and Ophthalmic
Lenses

1956
Stanson Chemicals
Edgewater, New Jersey
Detergent for Washing Clothes, Dishes and
Painted Surfaces

1955
Carl M. Friedel
Pocatello, Idaho
Game and Game Pieces

1948
Synthon, Inc.
Cambridge, Massachusetts
Cotton Yard Goods

1954
**Thermal Research & Engineering
Corporation**
Conshohocken, Pennsylvania
Air Heaters, Heat Exchangers and Furnaces